TATE MODERN

In Construction

Cv/Visual Arts Research Volume 69

Tate Modern
In Construction

ISBN 1-904727-64-6
ISSN 1476-9980

This interview was first published in
Cv Journal of the Arts
(London: The Artist's Journal Ltd 1989)

British Library Cataloguing in Publication Data.
A catalogue record of this book is available from the British Library

A digital format publication produced by
Cv Publications, Barley Mow Business Centre,
Barley Mow Passage, London W4 4PH
www.tracksdirectory.ision.co.uk

Cv/VAR Interview
The transcript of the original recording was checked,
amended and approved by the featured subject for publication.

Cv/Visual Arts Research

The survey began in April 1988 as interviews with jewellers, fashion designers and furniture restorers, based at Old Loom House in Whitechapel, launching a quarterly review *Cv Journal of Art and Crafts*. *Cv Journal* was published to 1992 and the collection of interviews, features and reviews provided the foundation of the Cv/Visual Arts Research archive and subsequent publications. Following *Cv Journal* the data-base shifted towards electronic publishing, allowing a greater flexibility of communication.

Cv/VAR addresses the fields of academic research, galleries and museums worldwide, and a non-specialist readership. In this respect the archive has been re-organised as a file system which may be accessed as individual articles or collated volumes, according to specific requirements. The data base is categorized as *Interviews-Artists; Curators and Collections; Crafts Directory; Small Histories; Social Studies and Studio Work*. Titles are published as conventional books and information files made by digital process as print on demand, as well as CDs and DVDs in Cv Publications' software catalogue.

As the Tate Modern site is developed at Bankside in 1997 interviews are recorded with Dawn Austwick, project manager, and Jeremy Lewison of the Tate Britain modern collection. They discuss the scope of the new galleries, funding issues, the new gallery's location and its future plans. There are thoughts on the diversity of the London Tates, and disposition of its collection.

Contents

Project manager Dawn Austwick on the
Bankside site in development 6-13
Interview with curator Jeremy Lewison
on exhibitions and presentations
planned in the two London Tates 14-19

fundraising - so the National Lottery work we've done, I led. If there's a particular target donor that I might have some coincidental relationship with, or whatever, or it's a prototype that's involved with them, but no more than anyone else in a sense. Where I'm very involved with fundraising is in the strategic direction, in terms of - what is the time that we need to raise funds and review progress? And managing that within the framework of the whole project.

How secure is a pledge? Is the Lottery funding solid?

Well I suppose, at my most conservative, I would say that no money is secure until it's in our bank account, and there's a hierarchy of how secure you think it is. If you take Lottery money, even that could be revoked technically, if the Lottery collapsed, and we might not get the rest of our money, though we've already had some.

But the Tate has to feel happy before it signs building contracts?

Yes, that is correct. The total project will cost us £130 million, of which we have secured £100 million. Now we couldn't say that that entire £100 million is without any risk whatsoever, because that £100 million will include pledges from donors who will say,

TATE MODERN
IN CONSTRUCTION

'We'll give it to you over five years.'

They set the terms?

Yes, and we might have had installment one and installment two, and then there's three, four and five to come. It's conceivable, just as in any business arrangement, that they could go belly up.

But you have contingency plans, life rafts?

The contingency is that we have sufficient money in the bank to deliver, and sufficient irons in the fire should some fall through. We don't actually count a pledge as firm until it's all written and documented, and there's a contractual agreement. Some of our donors just write us a cheque on account. For example there are a number of people who have said they will give us money, some have said how much, others simply promised to give. None of that counts against our total.

And so you have to go on and on, raising funds?

It basically moves from starting an opening negotiation, and that doesn't count in your calculations, it's just part of the target that you've got to achieve. Then you think your percentage evaluations of success increases as you go through. An offer from someone that's a verbal offer, from one source you would say that's ninety five percent secure; from another source you would say,

TATE MODERN
IN CONSTRUCTION

hang on, that's only fifty percent secure. All those sorts of calculations go into that line of thinking.

It's complicated.

It is. It feels like juggling different balls, and it changes all the time. One of the real mistakes you can make in a project like this is believing you can run it like a computer programme, because the situation changes from day to day and week to week. The fundraising might be full steam ahead for six months and then hit a problem. And you never know where it might come from.

But if you're looking to open in the year 2000 and you have two years to complete the building, and then to fit it out?

Yes, the construction programme is twenty three months, from summer '97 to summer '99.

The architects Herzog and de Meuron have done their job?

They've done the bulk of it, but they stay on site through construction as well. The majority of the work of the design team, in design terms, will be completed by the summer, obviously. There are elements of fit-out that we're not doing yet; for example, the detail of precisely how the educational facilities will look. I mean we know where the lavatories are, where the rooms are, but how we configure those spaces, we will actually leave till a little later.

TATE MODERN
IN CONSTRUCTION

The gallery spaces are where?

Levels three, four and five. If I start you at the bottom level one is the entrance area and combines the Turbine Hall, which if you look at those black and white photos, that's it. It is an astonishing space.

You're retaining the drama of that aspect?

Absolutely, it's even emptier now. It's five hundred feet long, about one hundred feet wide, and one hundred and twenty feet tall.

Who spotted it first - Nick Serota?

No, actually. This is mythology that predates me. It is said somebody called Francis Carnwath found it, who was the previous administrative director of the Tate. He was sent off to find sites and came back one day to say, 'I've found this extraordinary place, come and look at it.' On level one the Turbine Hall in effect becomes a rather extraordinary covered street.

Like an arcade?

That kind of downgrades it a little bit, but, absolutely, in that it could be open when the gallery's closed. It could be a grand meeting place. You can get to it from stage one, which is the western entrance. If you're coming from the north you come from a level above.



TATE MODERN

IN CONSTRUCTION



Examining the plans

This is looking at the northern entrance, which is on level two.
This is level one, the main west entrance. You come down a huge
ramp that brings you down to the bottom of the building. All our
ticketing and information will be in this area. The whole of this
area is the main gallery building, including the schools area, con-
veniences, shop, all down here. If you come from the north, you
come in either side of the chimney, across onto a bridge which
runs over, and either come down by the lift or the stairs. In the
long run there'll be an entrance from the south, where the big
gates are presently. This is an auditorium, cafe and bar area, a
film seminar room, the loading bay area and back of house facili-
ties. Here is level three, the first area of galleries with circulation
all in the central area, vertically. Escalators run all the way up,
and the central staircase. This is a concourse area in effect. The
gallery space is basically two wings on each floor; level four and
five are all gallery spaces.

A considerable space then?

Yes, we get more than at Millbank at present. Whether we do
level four will depend on how much money we raise; over £130
million, or we'll hold it as a shell.



TATE MODERN
IN CONSTRUCTION



The excitement of it is what you'd hope to make work?

Absolutely. It more than doubles our display facility, which is fantastic. The soaring tower in the long run, will have a high speed lift to a viewing platform. The light beam sits on the top, which first and foremost creates double length spaces in these galleries, and brings daylight in from either side.

The big problem, and to avoid a split, must be shifting visitors to the new gallery from Millbank. You need a regeneration process of the South Bank area to persuade people to come down here?

Well I think it's very interesting, because if you actually walk along the South Bank of the river, starting say at County Hall, you can go right down past Tower Bridge to Butler's Wharf, and you can trace pockets of development all the way up. Then there's the vacant site that the Opera House is going into, Hays Wharf Galleria and the London Dungeon. Southwark Cathedral and the Clink area, Southwark Bridge, The Globe and us. So actually there's quite an interesting development already, of, if you like, cultural attractions.

That's one way of moving down the river, what about going to St.Paul's Cathedral and coming across?

TATE MODERN
IN CONSTRUCTION

That's the other element. In terms of tourism there's an east-west axis, then north-south. The north-south axis for Bankside goes from St.Paul's, the Museum of London and The Barbican across to The Tate at Bankside and The Globe. For that to develop, and I think that the Tate is going to succeed in terms of its visitors regardless; for London as a whole at the moment there's too much tourism focused in the West End. Everybody agrees it's congested; the focus of London First and the London Tourist Board is to develop new clusters. To get that north-south one happening we need the footbridge, in my view. And what that does is it opens up a series of different pedestrian experiences, which we don't currently have. The great thing about the river bank is you can walk the whole way. There's a project to deliver a new foot bridge across the river which we're involved in. Fosters Associates have just won that, subject to a millenium bid.

Has the Millenium Project at Greenwich affected you?

Our fundraising from private sources is much more focused on individuals. Unlike Greenwich we're not looking to the corporate sector to provide us with capital funding, though clearly when the gallery opens we will seek to work with our corporate partners and new ones before the year 2000. But in terms of the capital

TATE MODERN

IN CONSTRUCTION

programme our absolute major focus has been the Lottery and Public sector; individuals and Trust organisations, and that's a pretty recognised route for capital funding.

Jeremy Lewison (JL), Acting Keeper of the Modern Collection, Tate Britain, Millbank. 06.03.97

Cv/VAR. Moving the whole modern collection to Bankside, which I assume includes post-war British...

JL. No, you've already made two assumptions which are incorrect. First of all, we're not moving the modern collection. The collection is a central resource which can be displayed on any one of four sites Millbank, Bankside, Liverpool and St.Ives, and if there's any one place where the collection is based, it's our new store at Southwark. From the year 2000, when Bankside opens, we will be displaying there British and Foreign art - or art from around the world, if you like, from 1900 onwards. And at Millbank we will be showing British art from 16th century to the present day. 20th century art will be shown in both sites.

Will the visiting public move comfortably between the two Tates?

The visitor who wants to see 'The Story of British Art', will

TATE MODERN
IN CONSTRUCTION

come to Millbank; it's obviously a gallery which has a specialist feeling in that respect. Areas of foreign art from time to time will be shown at Millbank, but only as they illuminate a particular aspect of British art that we may want to focus on. So, for example, when you're doing a St.Ives display you may want to bring in some abstract expressionist art, to give a clichéd example. Those people who want specifically to concentrate on 20th century art, and they want to see a full international range of it, will go to Bankside. And there will be some people who go between the two. There have been suggestions that maybe there would be a riverbus service at one point. There is talk, for example, of gaining permission for some kind of pier outside Millbank, and we already have a landing stage outside Bankside, though it needs rebuilding.

How long would it take to get from Millbank to Bankside?

Ten minutes in a car - through traffic, fifteen minutes. On a river-bus, ten minutes. It's only four bridges along. Inevitably some people might turn up at Millbank thinking they were coming to see the 20th century modern collection, including foreign art, but we would hope that our pre-publicity would be sufficiently good to avoid that most of the time. But we are keen to connect the two

TATE MODERN
IN CONSTRUCTION

galleries in that sense, so people can easily go from one to the other.

How does this change the exhibition programme? At the Tate Millbank the blockbuster exhibitions such as Cézanne in 1996 have attracted major audiences. Will that still continue on both sites? A major show at Millbank, and a major show at Bankside - it's a lot of work, investment and expense.

We will need to continue to put on exhibitions which we estimate will be popular, but at the same time, we feel there is a good art historical reason for doing it. And the same applies in both institutions. As far as Bankside is concerned the exhibitions programme will have to pay for itself, so while we will have some exhibitions which will be very, very popular, they will subsidize the other exhibitions which may not be so popular, but we feel are important to do. The same will apply to the Tate Gallery of British Art. We are currently looking into what kinds of programmes, and what sort of variety of programmes we should be doing. We will be doing exhibitions on a large scale, and mid-scale exhibitions which we haven't previously been able to do. At the moment our exhibitions are in twelve rooms; in the future we will do some exhibitions at twelve rooms, and at the same time

TATE MODERN
IN CONSTRUCTION

will do exhibitions which are six rooms, or four rooms, so that we can focus in on particular areas over a brief period of an artist's work, or even do exhibitions of artists who we feel we couldn't financially justify on a large scale, but feel their work should be shown, so we'll do it on a smaller scale.

We know that in recent years the public has woken up to contemporary art, and it is now a tremendous draw for a number of reasons, providing the case that you could probably use the new space at Bankside for very fresh art. Would you be thinking of that?

We are thinking of not only displaying the collection, and works of a 20th century historic nature, but we are also exploring possibilities of doing projects with artists, and dedicating some galleries to contemporary art exhibits. Here at Millbank we have the Art Now room, which we would continue to maintain. We will continue to do the Turner Prize display here, and we will continue to find space in the exhibition programme to do contemporary shows of British art. So there'll be a rich diet of exhibitions, which will include historic and contemporary work on both sites. And in terms of the display of the collection, on both sites again, we'll be dedicating a certain amount of space to contemporary work. More perhaps at Bankside than at Millbank.



TATE MODERN
IN CONSTRUCTION



t would be weighted in that direction then?

Not because we feel it's more suitable for Bankside, but we will have an increase of about 25% of space at Millbank over what we currently have, for the display of the collection. We're creating new galleries downstairs which will release space upstairs for the collection. But that is going to spread evenly over the whole range of the collection from Elizabethan times to the present day. So there will be considerable pressure on space for contemporary art at Bankside. It is our view to see British contemporary art within the context of art made in other countries.

With visiting artists from other countries?

When you say visiting artists, we could do projects with artists of other nationalities than Britain at Bankside, yes. And there is work by non-British artists already in the collection.

There's a broader art-historical question nagging here; coming to the Tate at Millbank one enjoys floating between the Constables and the Rothkos, and making connections between now and then. Will one be able to do that at Bankside, or will it only be the modern, new and contemporary? Maybe that's a result of the way the Tate has developed up till now, it has been described as five galleries in one.

TATE MODERN
IN CONSTRUCTION

Well of course the Tate was founded as the National Gallery of British Art, and then had foreign art grafted on to it, so to speak. But I think it is fair to say that you will not be able to make your own connection between Constable and Rothko at Bankside, but there's nothing to stop curators doing that, and devising a display which brings together pictures of different periods, in one or other of the galleries, if we felt it was an interesting thing to be doing. There's no reason, for example, why one couldn't put Hogarth with George Grosz. That's down to the imagination of the curator. What I'm saying is, the visitor won't be able to wander from Constable to Rothko in the same gallery unless we've put them there.

For further information about the Tate Modern, Bankside,
Telephone Tate Information on 020 7887 8730/1/2.

The interviews were used as source material for a feature
published in Artists Newsletter, June issue 1997

TATE MODERN
IN CONSTRUCTION

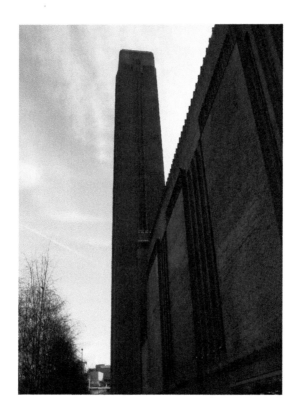

Tate Modern Millbank
Cv/VAR Archive

Cv/Visual Arts Research Archive

IMMA FOUNDATION

LAUNCH OF THE IRISH MUSEUM
OF MODERN ART

CENTRE DU VERRE

BOHEMIAN GLASS AT THE
MUSÉE DES ARTS DÉCORATIFS

Other titles from Cv/Visual Arts Research

Cv/Visual Arts Research Archive

SILVER IMAGE

EARLY BRITISH PHOTOGRAPHY AT
THE ROYAL PHOTOGRAPHIC SOCIETY

Cv/Visual Arts Research Series 48

For catalogue information of Cv titles in print contact:
Cv Publications . 10 Barley Mow Passage .
Chiswick . London . W4 4PH UK
Tel: +44(0)20 8400 6160
www.tracksdirectory.ision.co.uk